FIELDS OF VISION

The Photographs of Ben Shahn

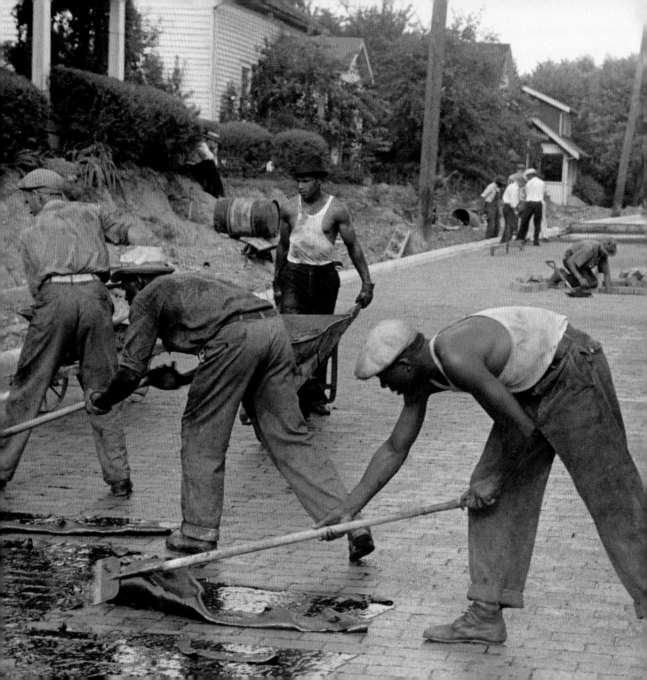

FIELDS OF VISION

The Photographs of Ben Shahn

Introduction by Timothy Egan

THE LIBRARY OF CONGRESS, WASHINGTON, D.C.

g

Copyright © 2008 The Library of Congress
Introduction © 2008 Timothy Egan
First published in 2008 by GILES
An imprint of D. Giles Limited
2nd Floor
162–164 Upper Richmond Road
London SW15 2SL
UK
www.gilesltd.com

For The Library of Congress:
Director of Publishing: W. Ralph Eubanks
Series Editor and Project Manager: Amy Pastan
Editors: Aimee Hess and Wilson McBee

For D. Giles Limited:
Copyedited and proofread by Melissa Larner
Designed by Miscano, London
Produced by GILES, an imprint of D. Giles Limited,
London
Printed and bound in China

**The Library of Congress is grateful for the support of
Furthermore: a program of the J.M. Kaplan Fund**

The Library of Congress, Washington, D.C., in
association with GILES, an imprint of D. Giles Limited,
London

Library of Congress Cataloging-in-Publication Data
Shahn, Ben, 1898–1969.
The photographs of Ben Shahn / introduction by
Timothy Egan.
p. cm. -- (Fields of vision)
ISBN 978-1-904832-40-9 (alk. paper)
1. Documentary photography--United States.
2. United States--Social life and customs--1918-1945--
 Pictorial works.
3. Shahn, Ben, 1898–1969. I. Title.
TR820.5.S483 2008
779.092--dc22
2007042285

Frontispiece: Repairing Route 40, central Ohio, August 1938 (detail).
Opposite: Child of a rehabilitation client, Maria Plantation, Arkansas, October 1935 (detail).
Page VI: Natchez, Mississippi, October 1935 (detail).
Page VIII: One of the few remaining inhabitants of Zinc, Arkansas, October 1935 (detail).

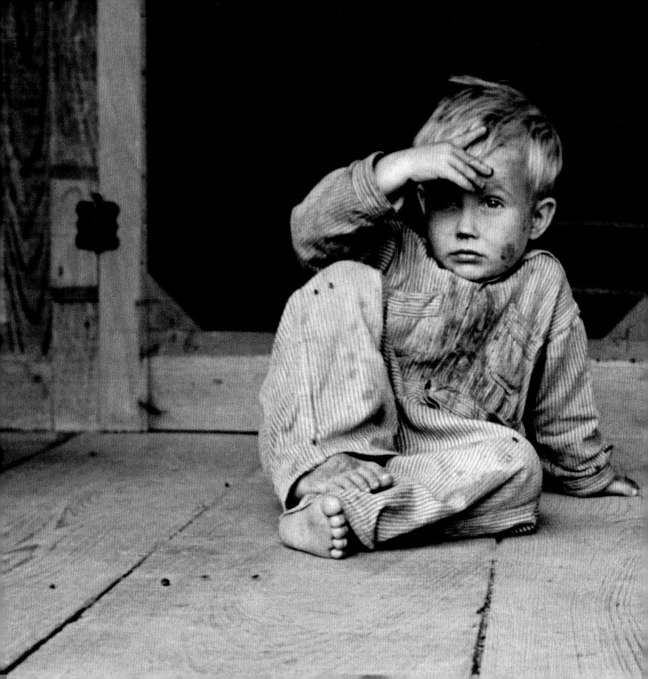

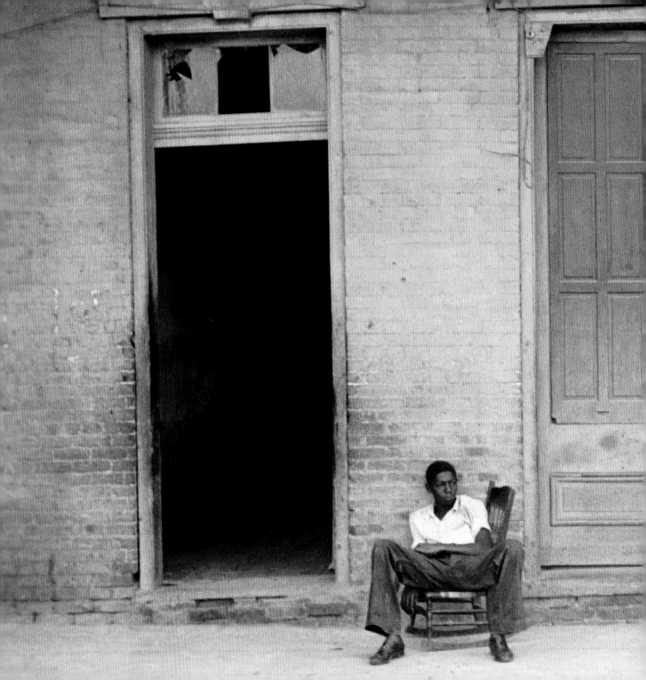

Fields of Vision

Preface

The Farm Security Administration–Office of War Information (FSA-OWI) Collection at the Library of Congress offers a detailed portrait of life in the United States from the years of the Great Depression through World War II. Documenting every region of the country, all classes of people, and focusing on the rhythms of daily life, from plowing fields to saying prayers, the approximately 171,000 black-and-white and 1,600 color images allow viewers to connect personally with the 1930s and 1940s. That's what great photographs do. They capture people and moments in time with an intimacy and grace that gently touches the imagination. Whether it is a fading snapshot or an artfully composed sepia print, a photograph can engage the mind and senses much like a lively conversation. You may study the clothes worn by the subject, examine a tangled facial expression, or ponder a landscape or building that no longer exists, except as captured by the photographer's lens long ago. Soon, even if you weren't at a barbeque in Pie Town, New Mexico, in the 1940s or picking cotton in rural Mississippi in the 1930s, you begin to sense what life there was like. You become part of the experience.

This is the goal of *Fields of Vision*. Each volume presents a portfolio of little-known images by some of America's greatest photographers—including Russell Lee, Ben Shahn, and Marion Post Wolcott—allowing readers actively to engage with the extraordinary photographic work produced for the FSA-OWI. Many of the photographers featured did not see themselves as artists, yet their pictures have a visual and emotional impact that will touch you as deeply as any great masterwork. These iconic images of Depression-era America are very much a part of the canon of twentieth-century American photography. Writer James Agee declared that documentary work should capture "the cruel radiance of what is." He believed that inside each image there resided "a personal test, the hurdle of you, the would-be narrator, trying to ascertain what you truly believe is." The

writers of the texts for *Fields of Vision* contemplate the "cruel radiance" that lives in each of the images. They also delve into the reasons why the men and women who worked for the FSA-OWI were able to apply their skills so effectively, creating bodies of work that seem to gain significance with time.

The fifty images presented here are just a brief road map to the riches of the Farm Security Administration Collection. If you like what you see, you will find more to contemplate at our website, www.loc.gov. The FSA-OWI collection is a public archive. These photographs were created by government photographers for a federally funded program. Yet, they outlived the agency they served and exceeded its mission. Evoking the heartbreak of a family that lost its home in the Dust Bowl or the humiliation of segregation in the South, they transcend the ordinary—and that is true art.

W. Ralph Eubanks
Director of Publishing
Library of Congress

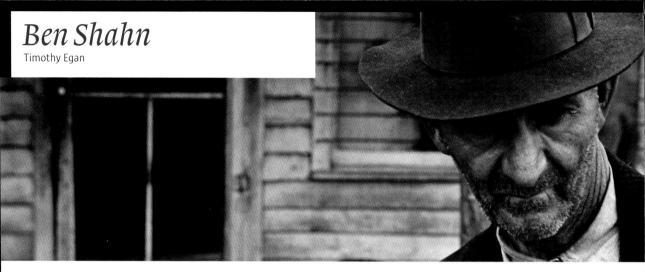

Ben Shahn
Timothy Egan

The American moment that Ben Shahn captured when he roamed the South and Midwest with a camera on behalf of the government in the 1930s was not something most nations would try to preserve for posterity. The country was on its knees, one in four adults unemployed, soup lines in the big cities, and homesteads dusted over in the midsection. Despair seemed woven into the very landscape. People looked older than their years. In the Pacific Northwest, a cop killed another cop over a few pounds of black-market butter. In Iowa, farmers desperate to keep the banks from taking another homestead grabbed a foreclosure judge, rushed him out to a nearby field and nearly succeeded in hanging him. In Texas and Oklahoma, where mountains of dust sometimes erased the noon-day sun, people were so hungry they were forced to eat brined tumbleweed.

But if the era of the Great Depression was indeed a "low, dishonest decade," as the poet W.H. Auden called it, you won't see that in the photographs of Ben Shahn. Yes, his pictures show the most corrosive details of poverty: a hollow-cheeked Kentucky coal miner, with no socks under his tattered boots; scabs on the face of an otherwise cherubic farm boy; an enormous empty cotton bale at the start of a hot day. You feel the texture of want. But you also see the humanity of these Americans, who were broken by the worst economic calamity in our history. You see the soul through the eyes. You see a future, or perhaps a glimpse of one, in a smooth young face next to that of a hardened older visage. No matter where he pointed his camera, Shahn could not help but find a telling detail that went beneath the surface. Sent to document the brutality of the depression, he came home with that, plus its heart. He looked at a child or a mother or a sharecropper at the low ebb of their lives, and he found something he wanted the rest of us to see. His subjects were not just discards. They were not just "Exodusters," as many farm refugees were called. They were not just people on the dole. They were not just "types."

As an artist, Shahn was considered a Social Realist. His pictures and paintings showed life as it was, not how his subjects or viewers wished it to be. Social Realism focused on the struggles of the working class. Shahn's affiliation with this movement and his leftist political leanings ultimately earned him a hearing before the House Committee for Un-American Activities in 1959, but Shahn was never a card-carrying Communist, and the hearing was largely a sham. His drug store, his rural road, his front porch, could never be Norman Rockwell's. But he was an optimist, in this sense: he thought if he showed you the human being behind the coarsened shell, you would be moved, as he was, to do something.

The pictures by Shahn in these pages belong to all of us; they are in the public domain, shot for a government agency—the Farm Security Administration—designed to promote a Roosevelt-era policy. But they have outlived their era, their singular purpose, even their context, because Shahn looked for something universal when he pointed his little Leica at a face or a field. One would not even call these pictures historic or vintage, though that's what they are in the narrowest of terms. One would simply call them what we call all good art: timeless.

The marvel is that Shahn did not consider himself much of a photographer. He was a painter, a muralist, a sketch artist and a provocateur. His life mission was to outrage, to inspire social change. He gave up the camera at the height of his photographic success. The pictures, however, would serve him for decades as inspiration for his other work. No matter the medium, his love of the underdog and his deep-rooted anger at injustice informed and sustained his work into his dying days.

* * *

Ben Shahn was born on September 12, 1898, to a relatively poor family in the Jewish section of Kovno, Lithuania, a place where the wrong political affiliation or simply the wrong casual encounter could get you jailed. Russian soldiers, stationed in town, would often harass Jewish families, throwing stones through their windows. His father, Joshua Hessel, was a wood craftsman, expert with his hands, but also a storyteller, and actively engaged in daily debate about the fate of the people clustered in one side of town, at the mercy of the Czar. His mother, Gittel Lieberman Shahn, came from a family of peasants. At a young age, she worked as a servant, and only learned to read and write much later, taught by her husband.

From his parents, Ben inherited a love of storytelling. They could connect narratives passed on from prior generations with the struggles of the day. Shahn's art would strive to do the same thing. According to his biographer, Howard Greenfeld, Shahn once told a friend, "Most facts are lies. All stories are true."

Ben was barely four years old when his father was arrested on a charge of circulating revolutionary leaflets. The family said he had been framed. Hessel was sent off to faraway Siberia, the edge of the world to a boy in small-town Lithuania. Left alone with three small children, Ben being the oldest son, Gittel moved the family to Vilkomir, a smaller town forty miles away, where she had relatives. A river divided the town and Jews lived on one side, non-Jews on the other. In the Jewish section, a fear of violent pograms pervaded. In Vilkomir, Ben first learned to draw. His grandfather, a big man who became a fatherly presence, encouraged him to sketch, to carve figures from wood, and to tell stories.

Another trauma soon shook the family when most of the town of Vilkomir was burned to the ground. The flames that swept through the snug village and took nearly every house stayed with Shahn forever—a memory of the haunting power of loss. This experience helped him later to empathize with people who saw their farms ravaged by nature. Ben was lucky: his family was living with relatives just outside of town, in a part that was not destroyed. Still, coupled with the serial harassment by violent anti-Semites, it seemed to be an omen. Their time in Vilkomir was coming to an end.

In 1906, the family packed up their belongings, said goodbye to all their friends and relatives and moved away to America, part of a vast wave of Jewish immigration—mostly from Eastern Europe—to the United States in the early part of the twentieth century. In the year that Ben's family arrived, about 150,000 Eastern European Jews came to America, and by 1910, New York City would have a Jewish population of more than one million. Like many other immigrants, the Shahns quickly found their tribe in the New World. They settled in the Williamsburg section of Brooklyn. The move brought the family back together, for Ben's father had escaped Siberia and made his way to the United States just before everyone else arrived. At eight years old, Ben needed to learn English, among other things.

The family enjoyed a few prosperous years, made possible by money saved through the carpentry work of Ben's father. But fire again made an appearance in their lives: it burned out the apartment where they lived and badly disfigured Hessel as he rescued two of the children from the building. Afterward, their luck seemed to disappear; the family was always scraping for money and respect.

As a young man, Shahn learned the trade of typography, working in graphic design. Though largely technical, this work would influence him later, when, as an artist, he started to combine print and images to make the kind of bold, stunning statements that were the hallmark of the Social Realists. By 1918, he was making $60 a week—very good money—with the promise of secure employment in a growing field. But Shahn turned away from a predictable future to pursue his education, following his curiosity through three schools: New York University, City College, and the National Academy of Design.

As a struggling young artist, he threw himself into the great ethnic stew of New York City in the flamboyant 1920s, equipped for the first time with a camera. He was starting to see photography as an art form. He shared a studio with Walker Evans, the great photographer whose influence, personal and artistic, is responsible for much of the work that fills this book. If Evans was a teacher and sometime mentor, New York City was the classroom.

The 1920s are known, in the shorthand that can define an era, as the "Jazz Age," a time when America would go on "the greatest, gaudiest spree in history," as the novelist F. Scott Fitzgerald wrote. The glitter, glamour and late-night histrionics of the swell set did not interest Shahn, however. He was in love with a city bursting at its seams with newcomers, immigrants of all sorts, building lives from scratch in back alleys and stoops and top-floor tenements. He photographed street scenes, huddled masses at work and play, children on a dirty back lot. In New York, he refined the style that would serve him so well during the Great Depression. Most importantly, he tried to show his subjects in context—mid-stride at midday, perhaps—shooting people in the act of life.

Still, it was primarily politics that animated him. The famous 1927 trial and execution of two Italian immigrant anarchists inspired Shahn's monumental series of paintings, "The Passion of Sacco and Vanzetti," in 1932. As a fellow immigrant, Shahn sympathized with the Italians—one a shoemaker, the other a fish peddler—and believed they had been framed in a murder and robbery case because of their politics and their standing as lowly foreigners. The Sacco and Vanzetti case came to symbolize the fight for justice among America's minorities and poor, and served as a catalyst for the growth of the leftist movement in America. The "Passion of Sacco and Vanzetti" remains Shahn's most famous work. The series of twenty-three gouaches and temperas drew huge crowds at Shahn's regular gallery in New York, strong reactions from critics, and praise from well-known intellectuals such as novelist John Dos Passos. Shahn became a name within the art world before his thirty-fifth birthday. According to "The Biography of Painting," a lecture he gave at Harvard in 1956, Shahn did the work, based on documentary photographs, with, "as rigorous a simplicity as I could command."

After working with the Mexican artist Diego Rivera on a controversial series of murals for the Rockefeller Center in 1932–33, Shahn moved to Washington, D.C., to start a new life in a new city, with other artists and photographers who wished to help a country in the midst of a deep economic freeze. This period, from 1935 through 1938, was his most productive as a photographer. It seems that the collapse of the American economy brought out his best work with the camera.

There had been other recessions, panics, and crashes in American history. In fact, they were a regular part of the economic cycle. But nothing took the country down so low, or for so long, as the Great Depression. Economists still debate its origins and its exact starting point, but in the popular imagination, the depression began with a crash on Wall Street in the fall of 1929. "WALL ST. LAYS AN EGG," read the headline of the show-business paper, *Variety*. The market lost 40 percent of its value over three weeks. Though only a fraction of Americans owned any stock, the crash had a spiral effect, and a contagion of fear eventually consumed nearly every bit of commercial life, from the Main Street merchant to the High Plains farmer to the Wall Street tycoon. Banks, heavily invested in stocks, collapsed in short order. Thousands simply closed their doors and went under, taking with them the hard-earned savings of people who knew little about distant speculations on Wall Street. Urban shanty villages called Hoovervilles sprang up in the cities, full of families living like Dickensian beggars under tarpaper roofs.

In the fields and farms, just as on Wall Street, the economy imploded. Crop prices fell through the floor, leaving farmers without a way to cover their costs. To make up, they plowed more grass in the Great Plains, stripping away the protective layer that had held the soil in place for eons. Without its ancient weave of sod, the earth soon took to the skies, with dust storms that blew, on several occasions, from Kansas to New York City and out to sea. One storm blew dust into the White House and onto the marble floors of Congress.

The election of a new president in the fall of 1932 offered hope. Franklin D. Roosevelt built his campaign around "the forgotten man at the bottom of the economic pyramid." It was an appeal that went to the heart of Ben Shahn, as well as to that of his old friend, Walker Evans. They wanted to do something, and in Roosevelt's farm policies, they found their mission. The Resettlement Administration, later renamed the Farm Security Administration (FSA), had been set up to help people whose farms had gone under to start a new life, on new ground, using more sustainable methods of farming. But it was a tough sell to a skeptical Congress.

In 1935, facing resistance to his agricultural program, President Roosevelt asked Roy Stryker to help him promote FSA policies. Stryker, a Kansas-born economist, came up with the idea of creating a photographic record of the ravages of the Great Depression. The idea was to draw on the nation's reservoir of good will, by showing people what had happened to sharecroppers, tenants, and various landowners broken by the drought or hard times—"introducing America to Americans," as the in-house slogan went.

Stryker hired some of the most talented young photographers of the day—Dorothea Lange, Arthur Rothstein, Carl Mydans, Gordon Parks. Smart enough to trust their instincts, he never told them specifically what to photograph, though he did issue guidelines. He wanted the pictures to show people's ragged link to a broken land—a bankrupt homestead, a fallow field, an orchard in disrepair—to back up the president's idea of establishing a new rural economy. To this end, he told his crew to shoot everyday life—cooking, sleeping, praying,

socializing. Shahn was lucky to fall in with these talented documentarians. Like him, they had a strong social conscience. And they found a president who wanted to put them to work.

The job came along at a providential time for Shahn. Like other Americans, he was out of work, and out of savings—and he had a wife and two children to support. Stryker hired him in 1935—but not, initially, as a photographer. He joined the Special Skills section, a group of artists, designers, writers, and others who put the raw documentary product—pictures, film footage, statistics—into finished government propaganda. Essentially creative types, the dreamers as well as the laser-focused were put on the federal payroll to create art on behalf of policy. Shahn was paid $3,200 a year to start, a decent sum during the depression. As preparation, Stryker told him to travel to the rural South and elsewhere to get a feel for how hard times were affecting local populations. The camera was an appendage, of sorts, designed to help Shahn keep photographic notes for his drawings or posters. His official title was Associate Art Expert, P-3. There had never been anything like this in American government history before, and perhaps there never will be again.

He set out for the South in a Model A Ford, with a camera, and a new female companion, Bernarda Bryson. (Shahn left his first wife and eventually married Bryson.) His first journey into the heart of rural America was like that of any other iconic American in art and history, from Huck Finn to Jack Kerouac. He was open to a world he knew nothing about, open to the country, open to the people whose lives seldom merited special attention or even a pause for outside contemplation. It didn't take long for Shahn to realize that the camera would serve as more than an artist's aid. It generated the art itself.

Shahn used a hand-held 35 mm Leica with a right-angle viewfinder, which allowed him to face in one direction while pointing the camera in another—never confronting his subject head on. It was small enough to be portable and quick for any occasion. He had no other lenses, and often didn't even use a light meter. He shunned a flash, considering it "immoral." How could he expect people to understand the dreary darkness inside a sharecropper's home, or the dank, musty quality of

a garage housing a family of seven if it was lit artificially? He was drawn to the wet corners, the puddle on the floor, the shadowed edges. He liked the soft light at dusk on a face, or the harsh sunlight on a weathered hand at noon.

Shahn's style was casual. He avoided formal introductions and long explanations of the grand purpose of his photos. He schmoozed, he shot. The right-angle view-finder allowed him an element of anonymity, and sometimes he didn't even ask for a subject's permission before taking the picture, a practice frowned on today as an invasion of privacy. But Shahn wanted no pretense, no phony smiles or faux-noble poses. He wanted real life, as he said time and again. And real life required him to be a fly on the wall.

Though Shahn had no itinerary except for the open road, he found himself drawn to small mining towns tucked in the folds of hills, or cotton plantations, their luster long gone. He drove the back roads of Kentucky and West Virginia, looking for mines and the people who labored deep in the earth.

"In the South or mine country, wherever you put the camera there is a picture," Shahn said. That would not be the case for every photographer. But because Shahn was raised and worked in the big city, this rural life was another world. It all looked new to him, and it shows in what he chose to record. He drove rutted country lanes in Louisiana, Mississippi, Arkansas, and Alabama, recording the African-American faces that seldom appeared in the town squares. It was not just the down-and-out who became his subjects. He went into churches, to the steps of county courthouses, to city parks, to riverboats. He found it all mesmerizing, and even told friends he might never paint again. All his artistic energy flowed through the camera; documentary photography was his calling.

Returning to Washington with enough rolls of film to keep him busy for years, Shahn showed his boss he was ready for something beyond the Special Skills section. In fact, Stryker was ecstatic about his photos. Shahn had captured a region, and a people, in a way that went beyond the mandates of the Farm Security Administration. There was clearly something timeless, an authenticity, to the photos.

"Looking at his pictures, one is sure that he related to those people and knew something about what was going on in their minds and troubled lives," Stryker said in a later interview. "In some way people opened up. They opened up and said, 'Here we are.'"

Like a good story-teller, Shahn could employ a few critical details in a compact sketch to tell a broader story. So, for example, in a picture of a sharecropper family from Little Rock, Arkansas, you see two faces poking through a window: a child and an adult. The faces tell one story—of anxiety, of poverty, of despair—and the window frame tells another—the broken glass, the chipped and unpainted exterior, a rag stuffed into a corner to keep drafts out. He never meant his work to be subtle, Shahn said. But the pictures have such a natural quality that they actually look understated.

There is as much meaning residing in the background of a Shahn photograph as in the foreground. He would have a forlorn mother in the front of a picture, and the cautious, curious faces of children in the back. He shot one of the last inhabitants of Zinc, Arkansas, an unshaven man with deep-set eyes, with a sleeping dog on a porch in the rear. His main-street photos often showed something like the price of a soda or hamburger behind a passerby—a ten-cent hotdog in one, dresses nine for a dollar in another. Sometimes, a simple close-up would tell all, as in the picture of the rear of an old farm truck, its license-plate crumpled, the wooden fender chipped and frayed, a worn tire. He rarely shot landscapes or scenes in which people were absent, but when he did, the image could still pack a punch, as with the picture of Kimball, West Virginia. Dirty snow lines the railroad tracks, the trees are bare and cold-looking, and several rows of shacks sit huddled like refugees.

Shahn worked on various projects for the next few years in Washington, from murals and pamphlets to a documentary film with his friend Evans, who would become well known in his own right when he collaborated with James Agee on a book about southern poverty, *Let Us Now Praise Famous Men*. It would be several years before Shahn would hit the road again for another extensive photographic tour. And when this assignment came, in 1938, Shahn balked at first. Stryker wanted him to cover the farm country of southern Ohio, catching the harvest at its peak. Ohio? The big midwestern state fared better than most during

the depression. Full of quaint farm towns, it had little of the racial diversity of the South or hard faces of miners in the Kentucky hill country. Shahn wondered what he could find in Ohio that could match the visual drama of his tours through mine and sharecropper country. "It was neat and clean and orderly and I didn't think it had any photographic qualities for me," he said in a 1964 interview.

But Shahn went to Ohio with the same open mind, the same fresh eyes, the same sense of omnivorous curiosity that he had brought to the South three years earlier. He said he wanted to shoot average people, just as Stryker had instructed all his photographers to do. So he went to the traveling circus show, capturing Ohioans in their Sunday-school best, shirts and pants freshly pressed. He visited a county fair in the middle of summer, shooting women in print dresses and men with suspenders and natty caps. He captured a sidewalk scene, a pair of women walking by the Rexall Drug Store. He photographed people at baseball games, in the field, at lunch counters.

This was not Sherwood Anderson's Ohio, nor was it the Chamber of Commerce version. It was not the bleak, broken landscape of the South in 1935. Nobody appears hungry or particularly desperate. But people do look as if something is missing in their lives; they look as if they are just a paycheck away from joining those people in the South. The picture of a Post Office in Plain City, Ohio, is typical. In the foreground is a somewhat prosperous looking man staring at the camera as he appears to stroll into the building. Inside, behind the glass, we see another man in a t-shirt, glaring with mistrust.

Stryker liked the photos, but Shahn, who had initially seemed invigorated by the work , suddenly hung up his camera. Always prone to restlessness, he could be tempestuous and mercurial, sometimes lashing out at friends. He showed flashes of arrogance between periods of doubt. In the same passionate way that he had embraced the camera, he now renounced it. "Photography ceased to interest me," he said. "Suddenly, just like that, I felt I could only be repeating myself and stopped dead." The moment had passed.

In all, more than 250,000 photographs were made by various artists for the Farm Security Administration, making the 1930s and early 1940s one of the best-documented ages of our time, by some of the most talented people ever to labor for a federal paycheck. "We tried to present the ordinary in an extraordinary way," Shahn said in a 1944 interview. "But that's a paradox, because the only thing extraordinary about it was that it was so ordinary. Nobody had ever done it before deliberately. Now it's called documentary, which I suppose is all right."

Shahn returned to New York, his documentary photo days behind him. But his time in service to President Roosevelt was not over. He created a well-received mural about Social Security in 1940–42. The outbreak of World War II and atrocities by the Nazis gave him a fresh sense of purpose. He went to work for a new government agency, the Office of War Information, creating posters, murals, and pamphlets on behalf of the war effort.

After the war, New York's Museum of Modern Art held a major retrospective of Shahn's work. He was too young—not yet fifty years old—to be feted as a master of American art. But the exhibit gave some idea of how influential Shahn—a pamphleteer with camera and brush and lines of type—had become in the rarefied world of modern art. He would continue to paint, draw, and teach for the next two decades. Particularly in his later years, he was generous with his time and passed on all that he learned, lecturing at Harvard and other colleges. He died of a heart attack on March 14, 1969.

Art has its roots in real life, Shahn once said. Perhaps only true art—timeless, universal, accessible to any generation—can outlive the fads of its age, or the singular purpose of its time. It took a city kid just out of college, Arthur Rothstein, to shoot the iconic picture of the Dust Bowl —that family fleeing a brown storm, heading into their drifted-over bunker in the Oklahoma Panhandle. It took a woman with a generous heart, Dorothea Lange, to capture a mother at her most troubled moment in a refugee camp for so-called "Okies" in California. And it took an immigrant artist from Brooklyn, Ben Shahn, brought up in the oral storytelling tradition of his Jewish family in Lithuania, to find the authentic faces of rural America during its worst hard time.

"We just took pictures that cried out to be taken," he said. Perhaps. But they have proved to be so much more.

1

Sharecropper family, Little Rock, Arkansas, October 1935.

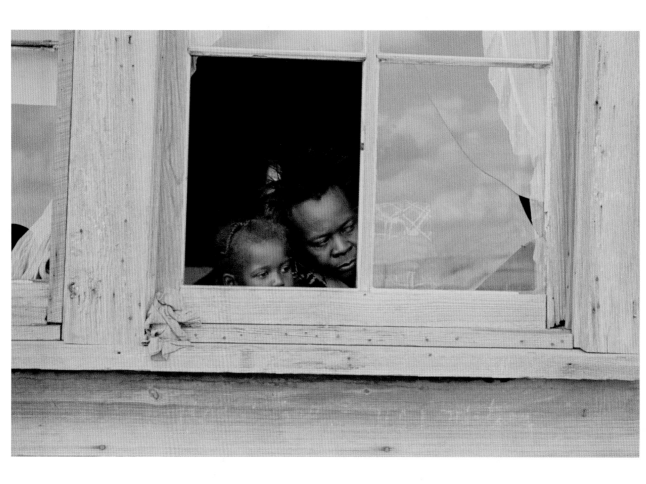

Wife and child of a destitute Ozark Mountains family, Arkansas, October 1935.

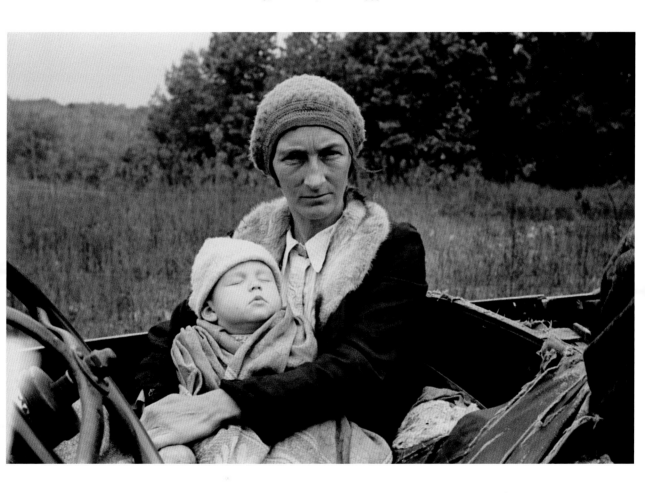

The family of a Resettlement Administration client in the doorway of their home, Boone County, Arkansas, October 1935.

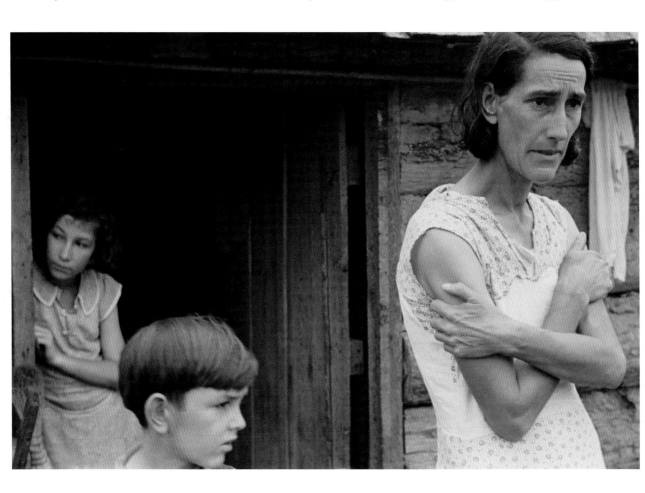

4

One of the few remaining inhabitants of Zinc, Arkansas, October 1935.

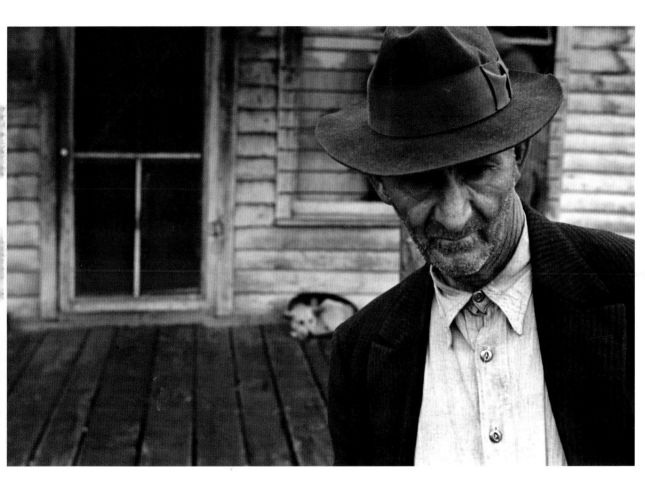

5

Picking cotton, Pulaski County, Arkansas, October 1935.

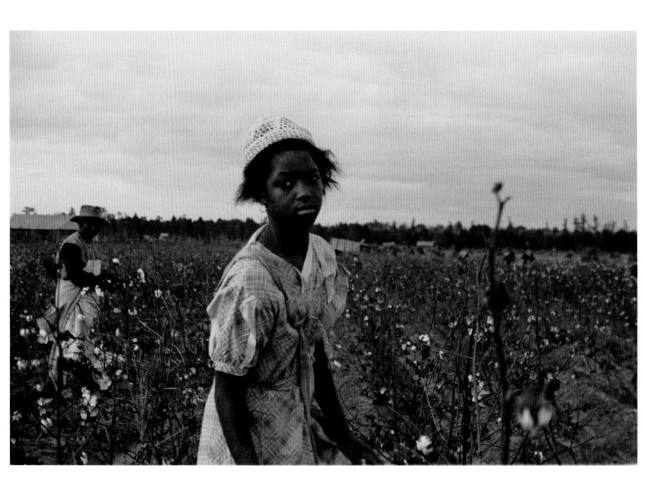

6

Coal miners, Jenkins, Kentucky, October 1935.

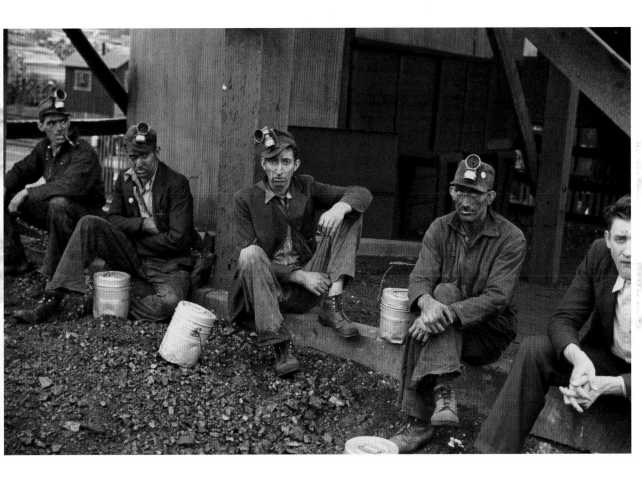

7

Cotton pickers, Pulaski County, Arkansas, October 1935.

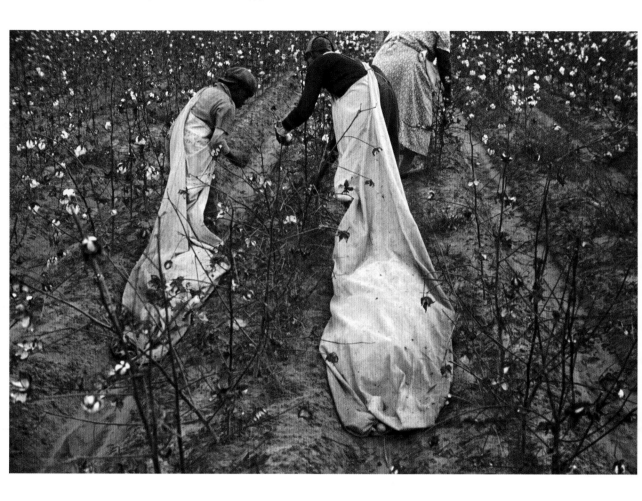

Kimball, West Virginia, October 1935.

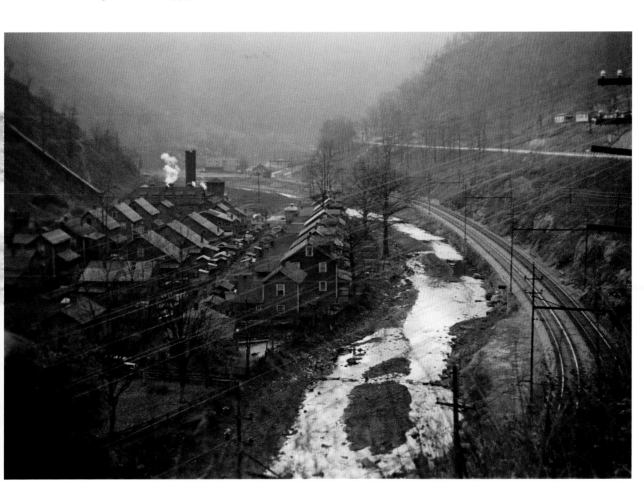

Trische family, tenant farmers, Plaquemines Parish, Louisiana, October 1935.

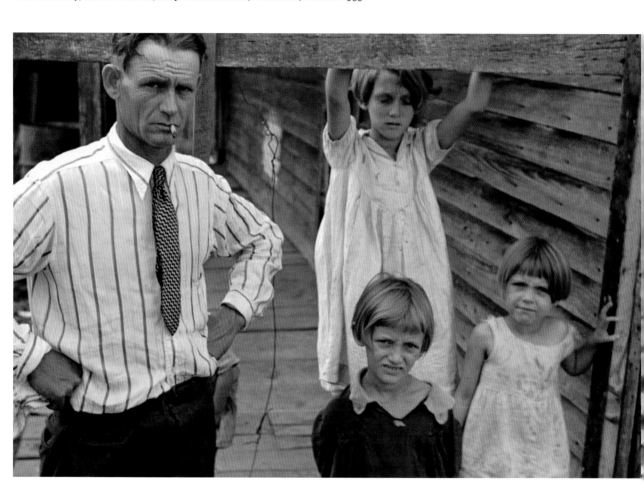

Rehabilitation clients, Boone County, Arkansas, October 1935.

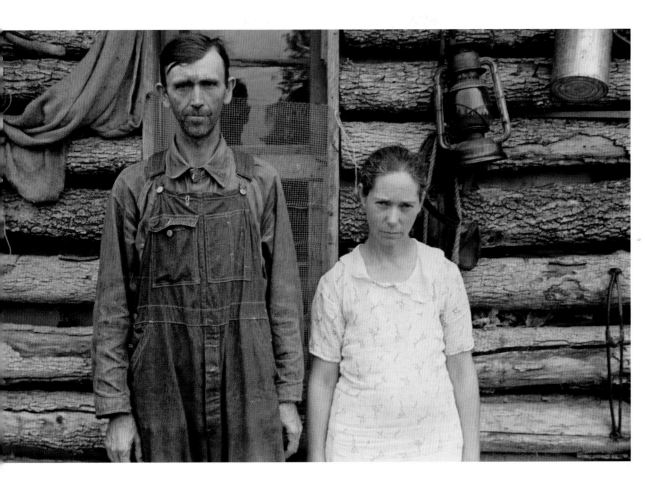

Waiting outside a relief station, Urbana, Ohio, 1938.

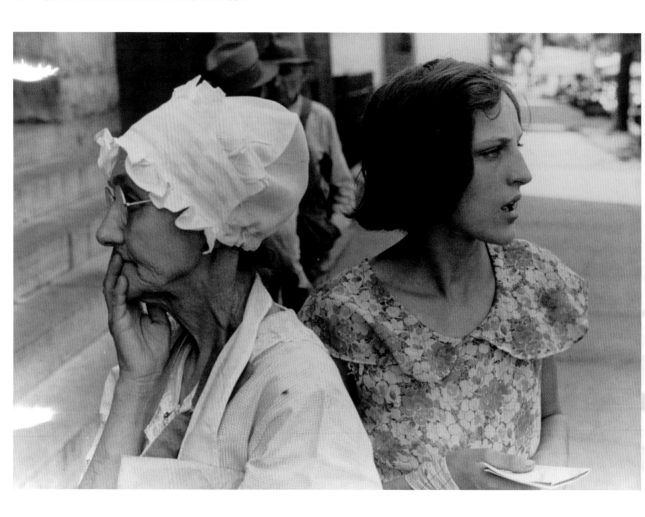

12

Young residents of Amite City, Louisiana, October 1935.

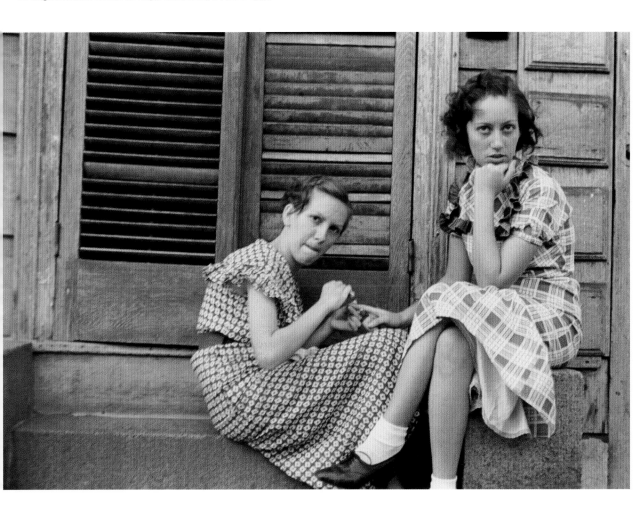

13

Coal miner's child, Omar, West Virginia, October 1935.

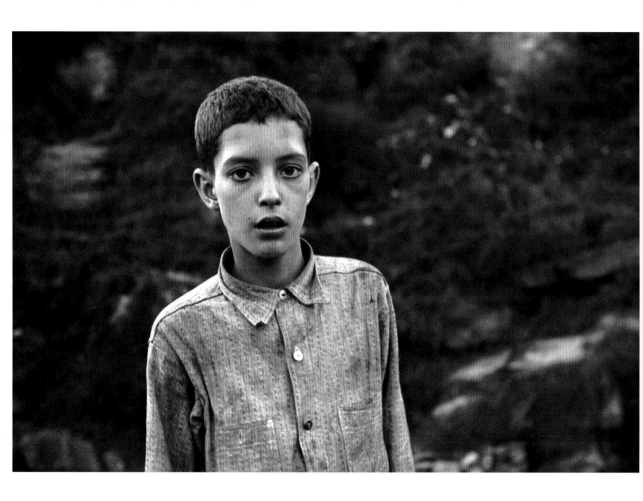

Omar, West Virginia, October 1935.

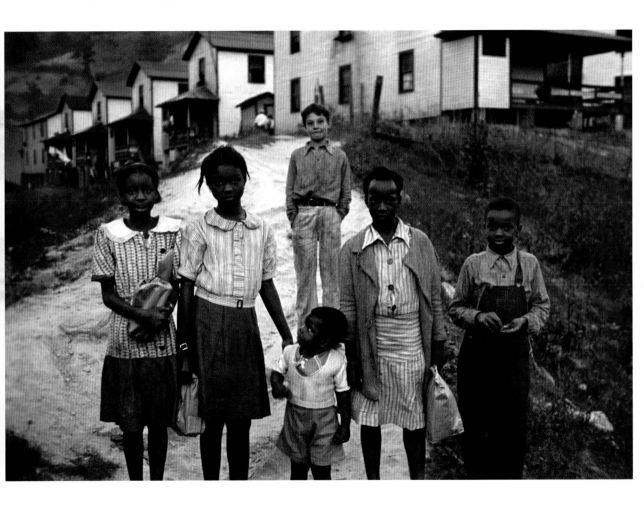

Post office, Plain City, Ohio, August 1938.

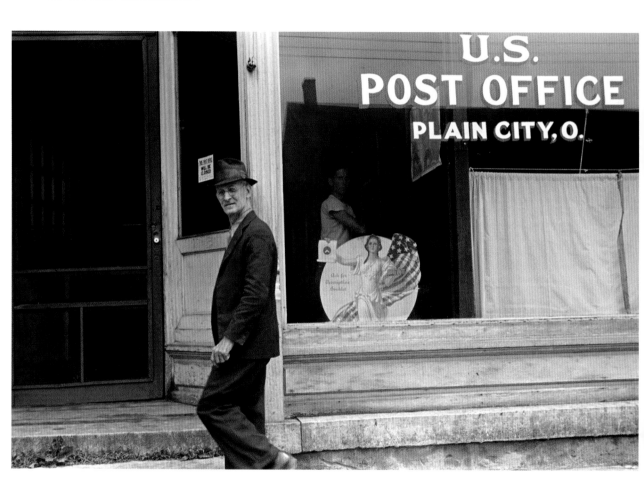

Family in Marysville, Ohio, summer 1938.

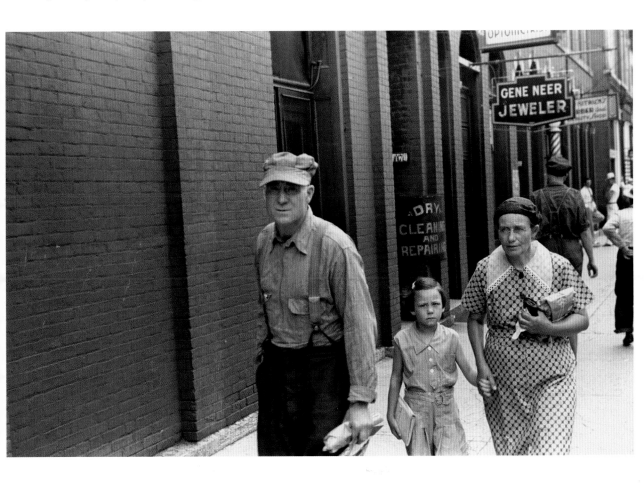

Newsboy, Newark, Ohio, summer 1938.

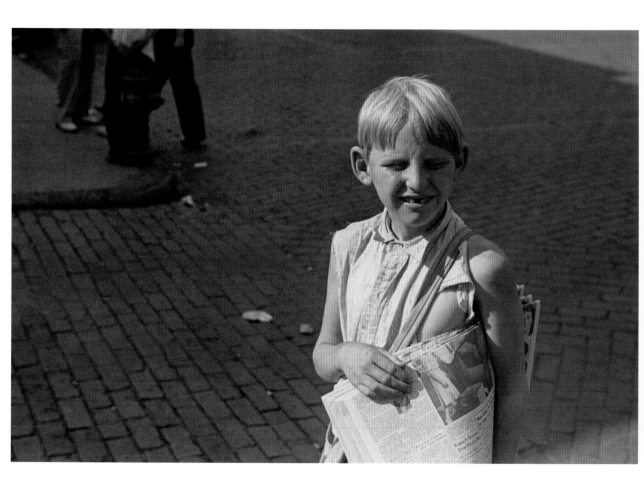

Blind beggar, Morgantown, West Virginia, October 1935.

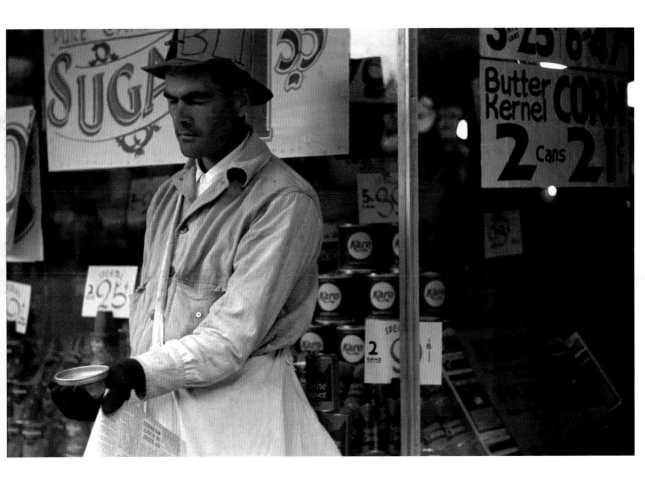

Citizens of Columbus, Ohio, August 1938.

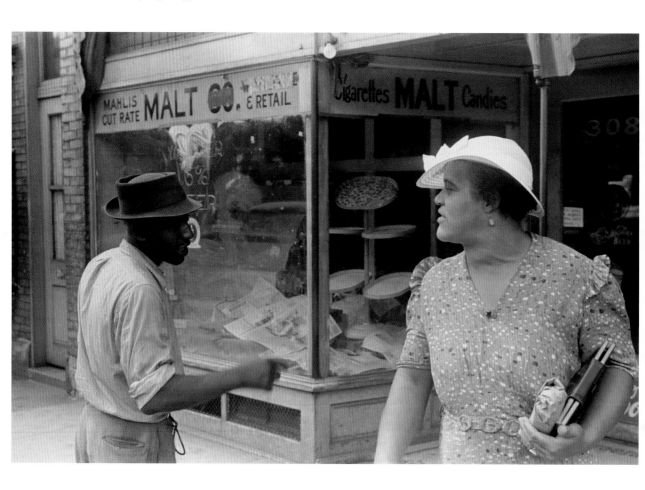

Food stand at Buckeye Lake Amusement Park near Columbus, Ohio, summer 1938.

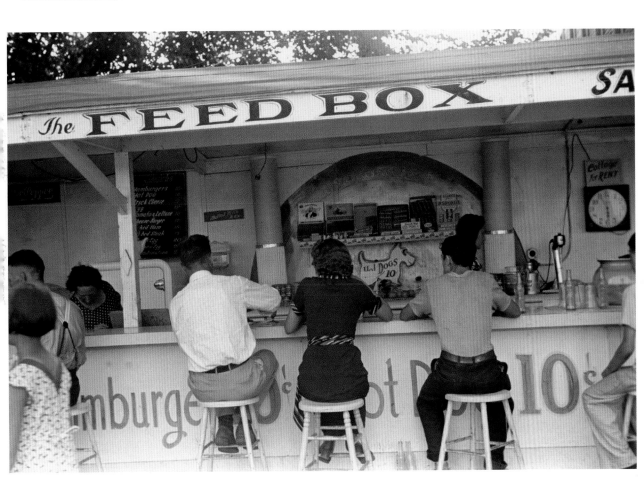

Medicine show audience, Huntingdon, Tennessee, October 1935.

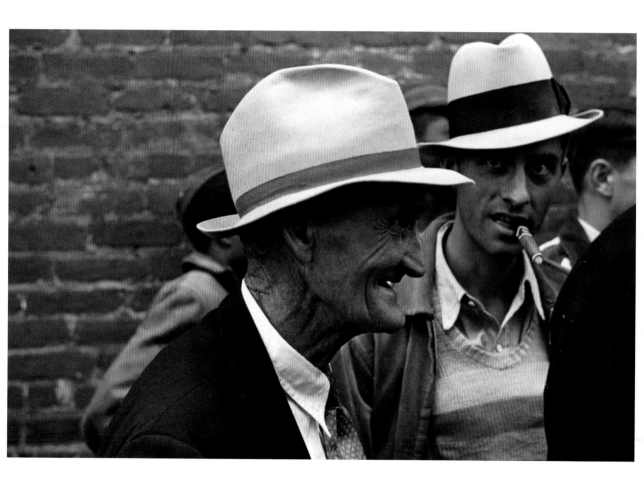

Amite City, Louisiana, October 1935.

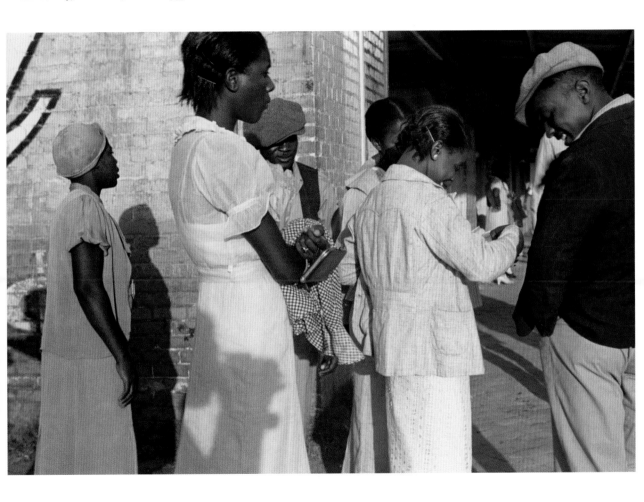

23

Interior of a blacksmith shop, Skyline Farms, Alabama, 1937.

Wagon outside a feed store, Plain City, Ohio, August 1938.

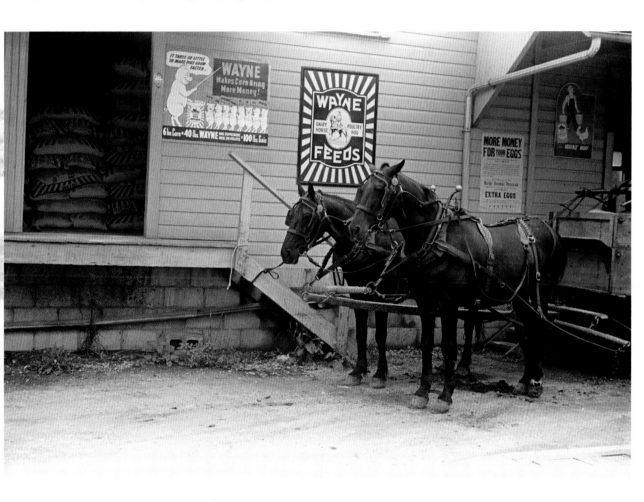

Medicine show, Huntingdon, Tennessee, October 1935.

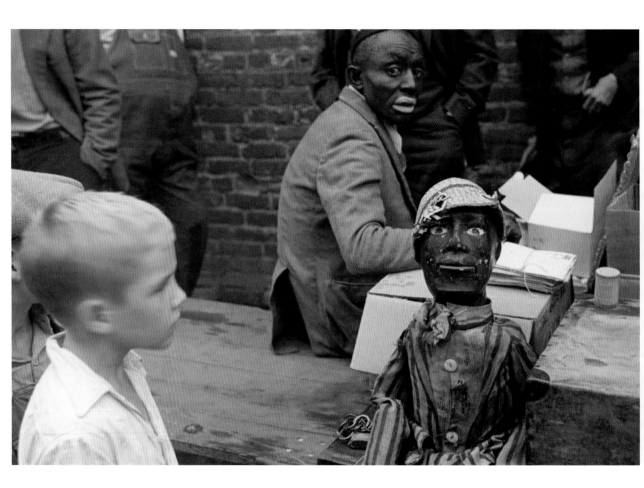

Children of a rehabilitation client, Maria Plantation, Arkansas, October 1935.

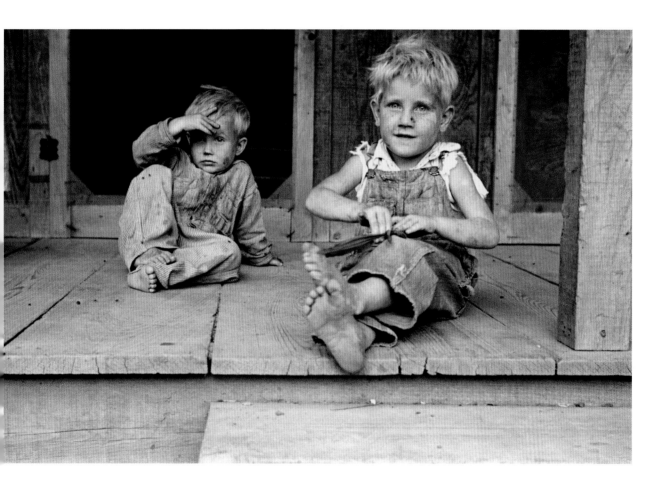

Street scene, Washington Court House, Ohio, summer 1938 (photographer's reflection visible at left).

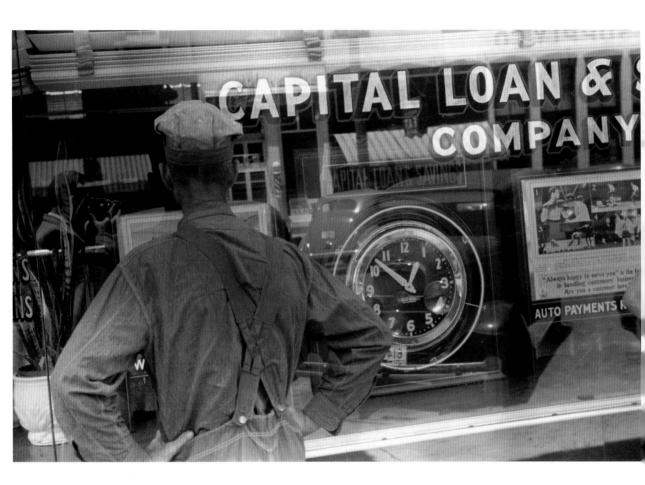

Itinerant photographer in Columbus, Ohio, August 1938.

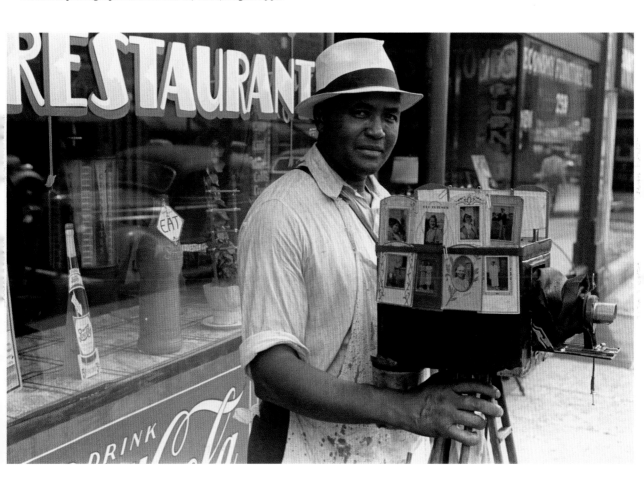

Creole girls, Plaquemines Parish, Louisiana, October 1935.

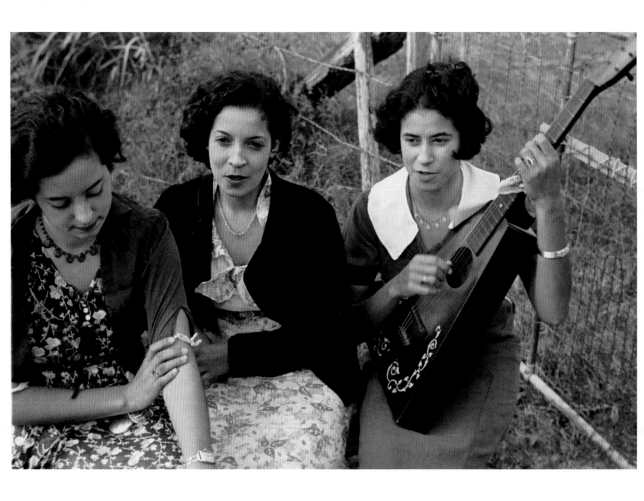

Daughters of Mr. Thaxton, near Mechanicsburg, Ohio, summer 1938.

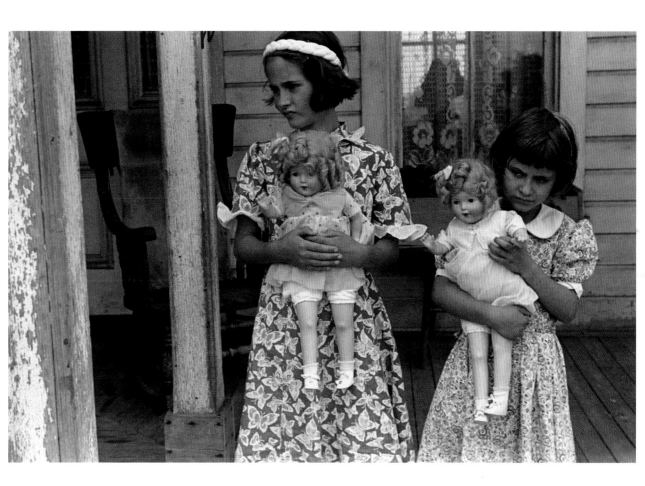

Cotton pickers, Arkansas, October 1935.

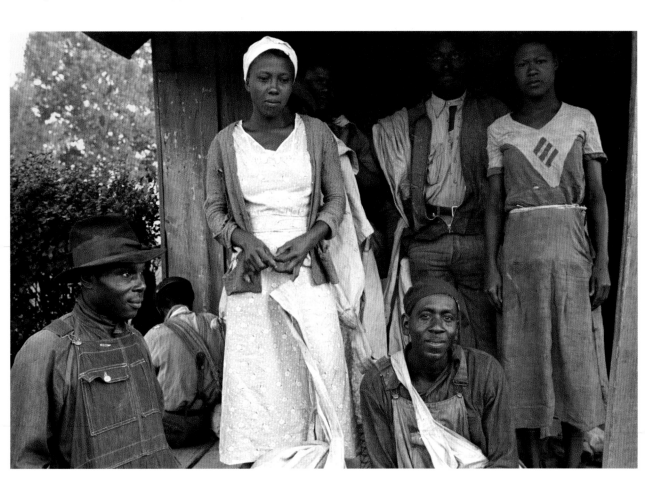

Secondhand clothing store, Columbus, Ohio, August 1938.

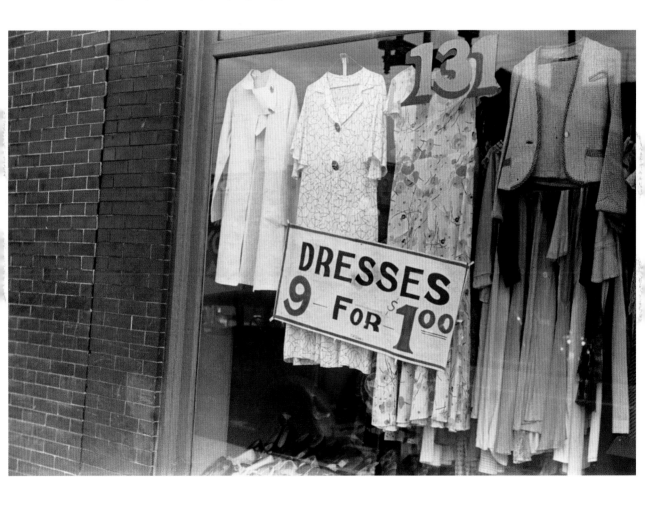

Natchez, Mississippi, October 1935.

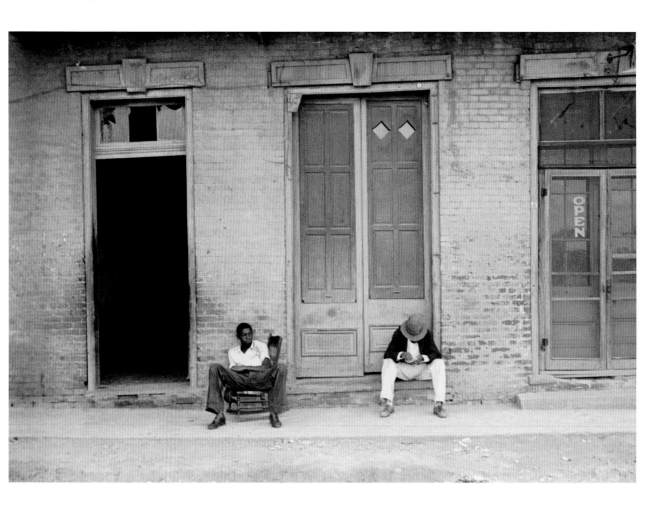

34

Lower Natchez, Mississippi, October 1935.

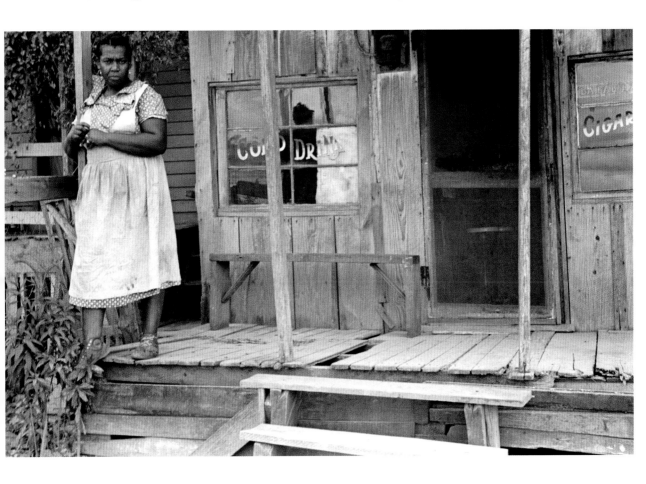

Unemployed trappers, Louisiana, October 1935.

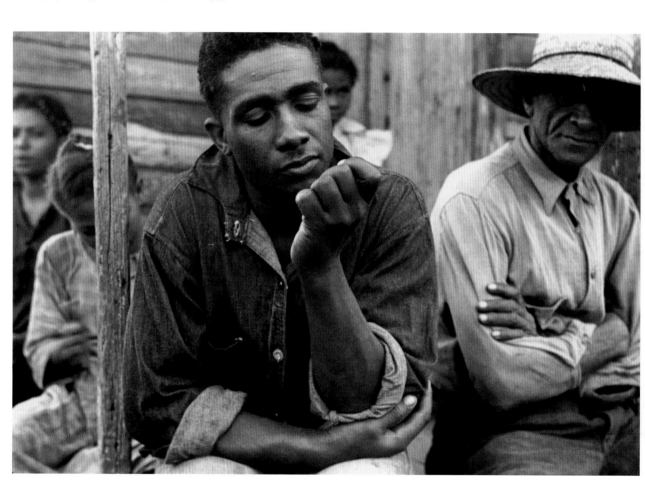

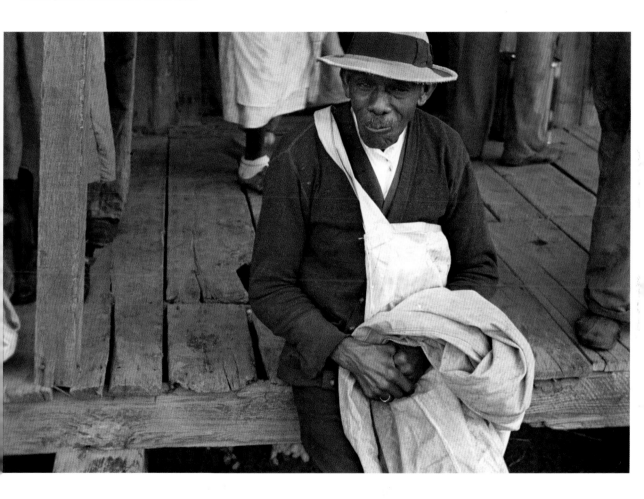

Cotton picker, Arkansas, October 1935.

Squatter's home, Arkansas, October 1935.

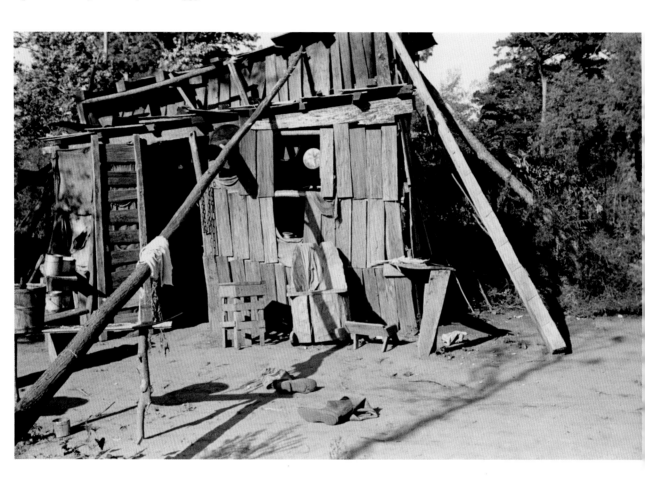

Newspaper mailbox at a Resettlement Administration Shenandoah homestead, Northern Shenandoah Valley, Virginia, c. November 1941.

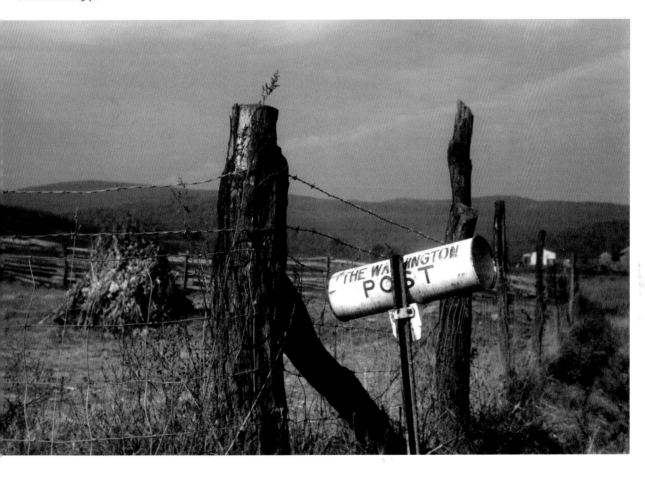

Maynardville, Tennessee, October 1935.

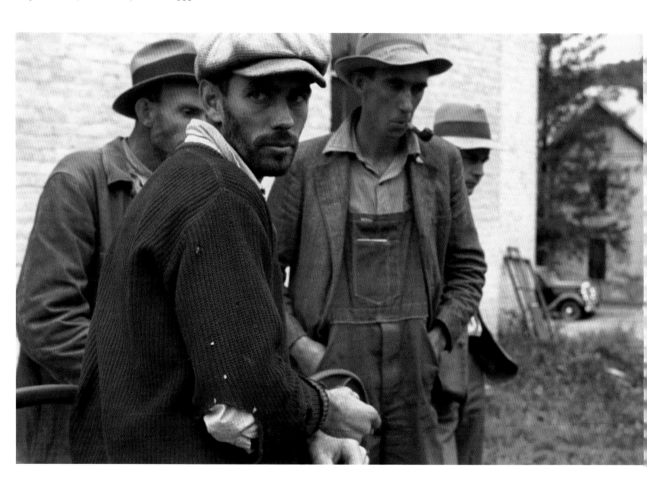

Bus station, Marion, Ohio, summer 1938.

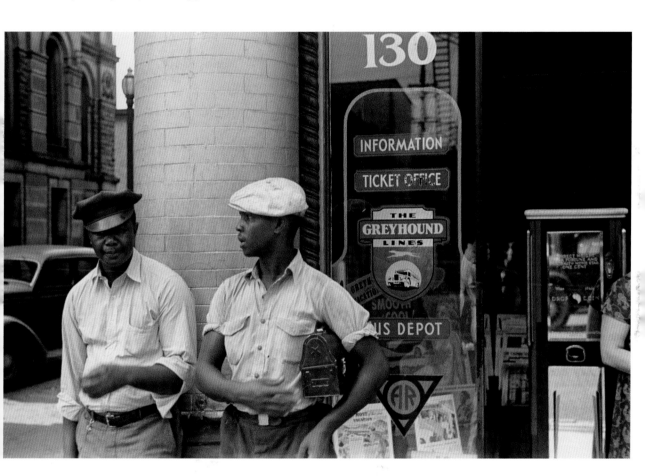

Advertisement, Marion, Ohio, summer 1938.

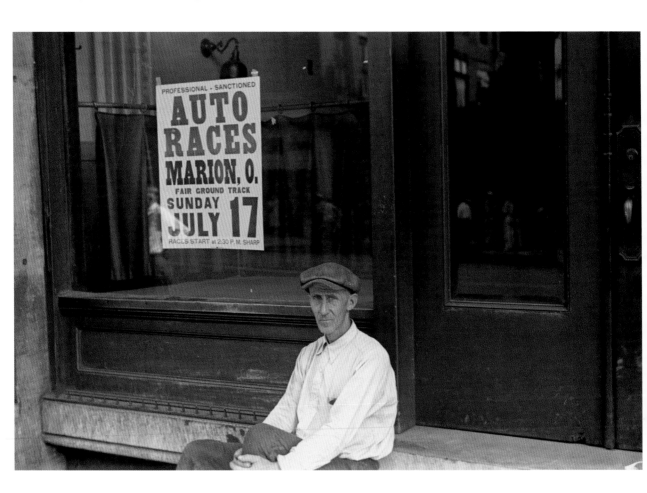

On Route 40, central Ohio, summer 1938.

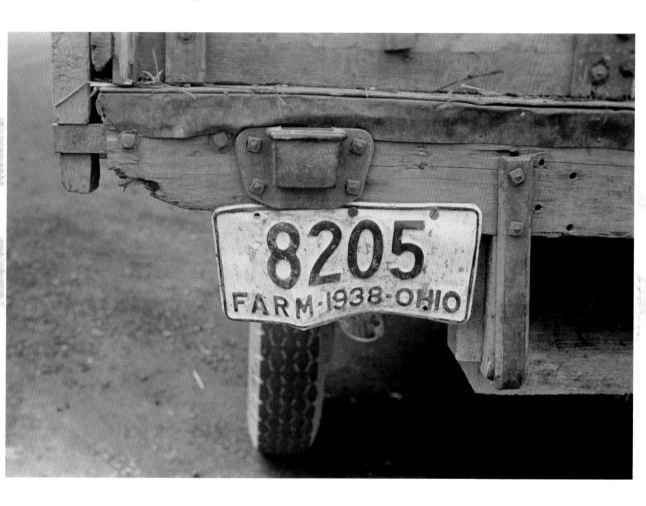

Reedsville, West Virginia, October 1935.

Sideshow at the county fair, central Ohio, August 1938.

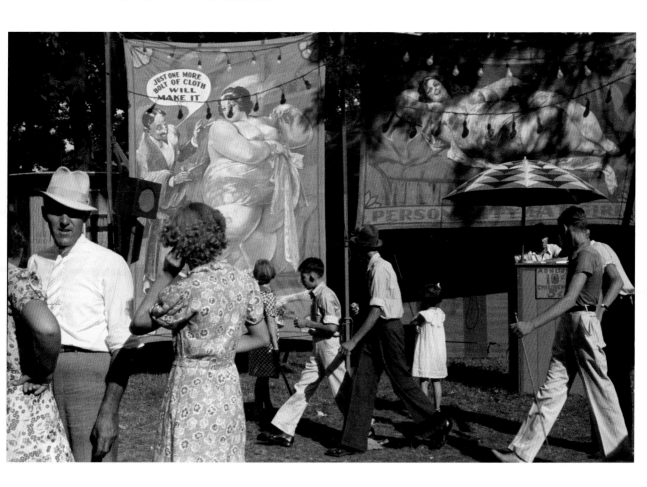

Farm people at a fair in central Ohio, August 1938.

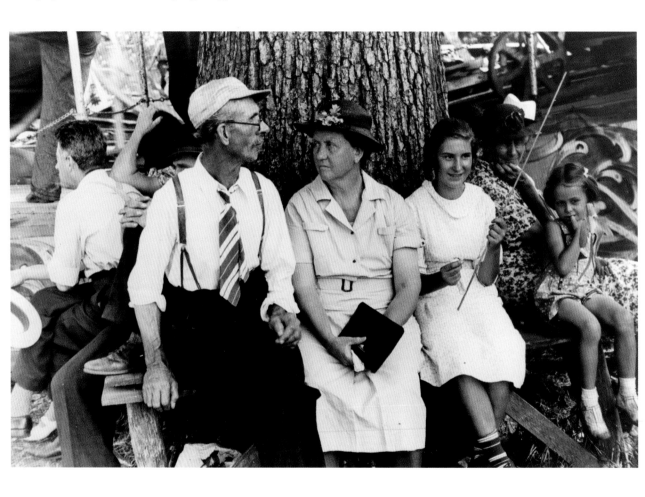

Schoolchildren, Red House, West Virginia, October 1935.

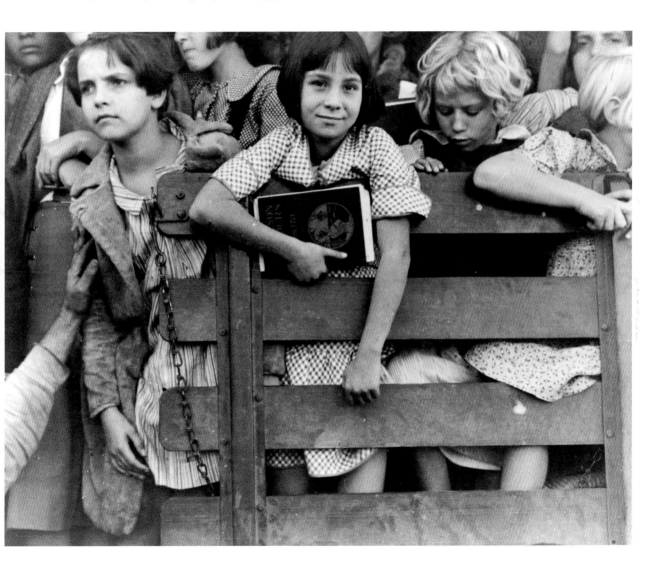

Tourist signs, central Ohio, summer 1938.

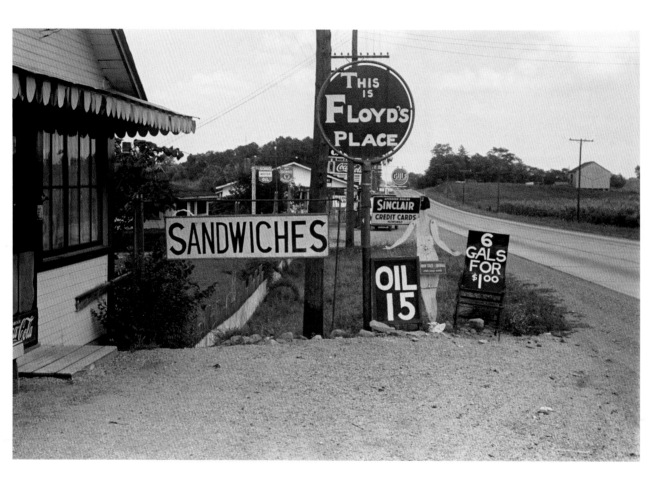

Repairing Route 40, central Ohio, August 1938.

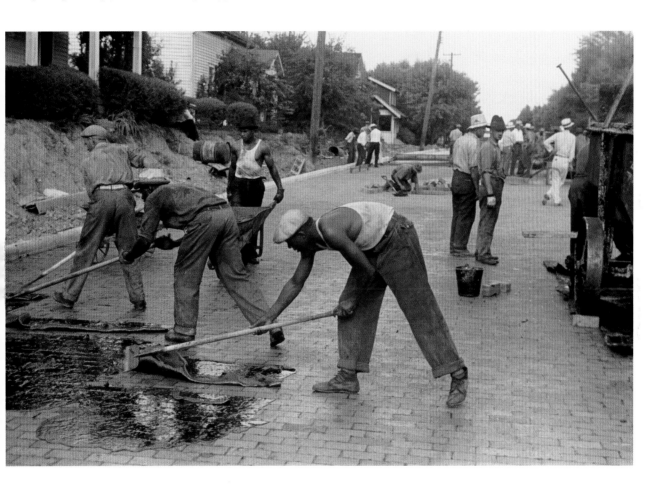

Sunday-school picnic, Penderlea Homesteads, North Carolina, 1937.

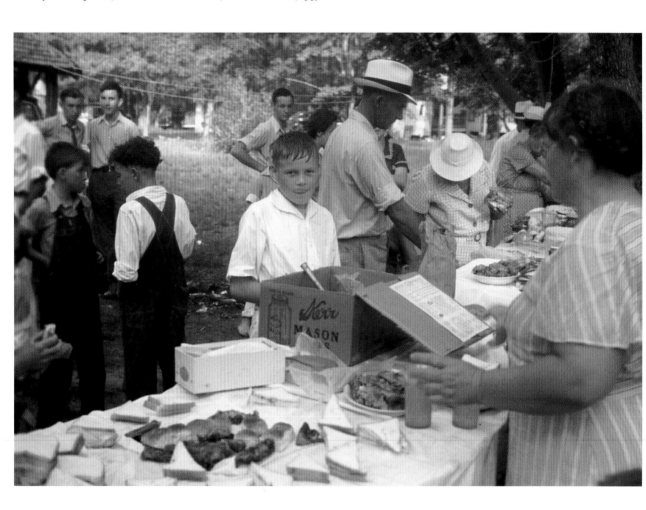

Drugstore window, Newark, Ohio, summer 1938.

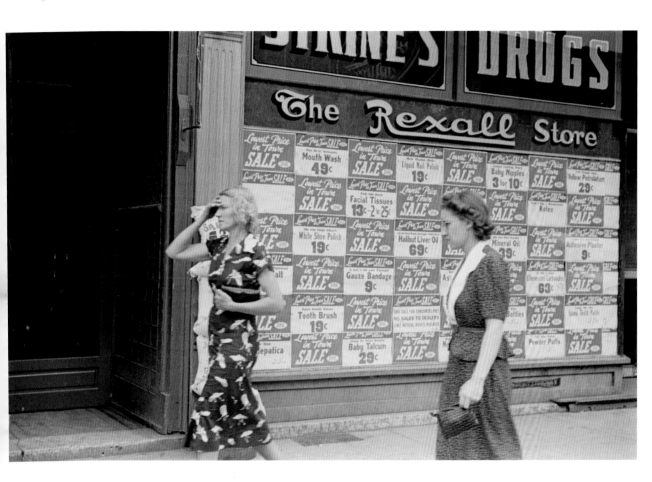

Images

The images in the Farm Security Administration–Office of War Information (FSA-OWI) Photograph Collection form an extensive pictorial record of American life between 1935 and 1944. In total, the collection consists of about 171,000 black-and-white film negatives and transparencies, 1,610 color transparencies, and around 107,000 black-and-white photographic prints, most of which were made from the negatives and transparencies.

All images are from the Library of Congress, Prints and Photographs Division. The reproduction numbers noted below correspond to the page on which the image appears. Each number bears the prefix LC-DIG-fsa (e.g., LC-DIG-fsa-8a16183). The entire number should be cited when ordering reproductions. To order, direct your request to: The Library of Congress, Photoduplication Service, Washington, DC 20450-4570, tel. 202-707-5640. Alternatively, digitized image files may be downloaded from the Prints and Photographs website at http://www.loc.gov/rr/print/catalog.html.